THEN *&* NOW

BUCHANAN COUNTY

THEN & NOW

BUCHANAN COUNTY

Brenda S. Baldwin and
Victoria L. Osborne

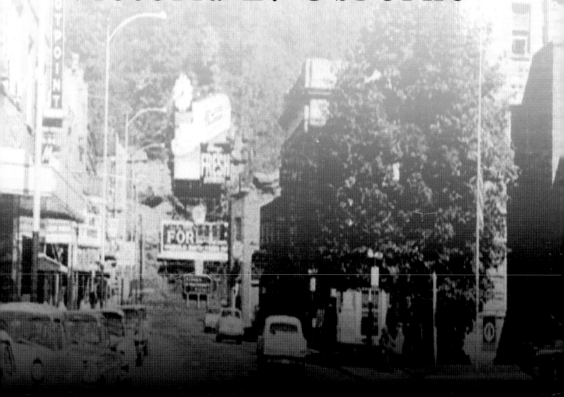

We dedicate this book to our family for inspiring us and to God for blessing and bestowing many gifts upon us in our journey through life. A special dedication goes to M.Sgt. A. L. Osborne Jr. for the 20-plus years he has dedicated to his country as a U.S. Marine. Words can never properly express the pride we take in you. We would also like to dedicate this book to all of those in the book who have made this possible.

This is also for the people of Buchanan County, who have continued with a way of life that is rare in today's society. They uphold all that makes our nation what it is—faith in God, devotion to family, assurance of good work ethic, and commitment to helping neighbors. Lastly, we would like to thank Arcadia Publishing for having the foresight to preserve the images of our nation.

Library of Congress Control Number: 2010929814

Published by Arcadia Publishing
Charleston, South Carolina

Printed in the United States of America

For all general information, please contact Arcadia Publishing:
Telephone 843-853-2070
Fax 843-853-0044
E-mail sales@arcadiapublishing.com
For customer service and orders:
Toll-Free 1-888-313-2665

Visit us on the Internet at www.arcadiapublishing.com

ON THE FRONT COVER: The Garden High School in Oakwood, Virginia, began in the 1920s as the Triangular Mountain Mission. The school was established by the Methodist Church. The county took over the school during the Depression. The school and its name disappeared in the 2001 school consolidation. The Appalachian School of Pharmacy was born in its place to bring academic excellence to the area. (Then image courtesy of the Norfolk and Western Collection at Virginia Tech; now image courtesy of the Southwest Virginia Historical and Preservation Society.)

ON THE BACK COVER: The large picnic gatherings of the United Mine Workers are a thing of the past. (Image courtesy of Charliece Swiney.)

CONTENTS

ACKNOWLEDGMENTS

Then and Now: *Buchanan County* is a historical treasure of a county's past, present, and future.

Thanks to Charliece Swiney of the Mountain Mission School for her endless generosity. We would like to also thank the following people and organizations for their help: Kenny Fannon, who is a great collector and preserver of the past and an endless source of knowledge; Bobby May, who has been a friend for over 20 years and has donated his pictures of the Buchanan County Police Department; and Joy Mining Machinery and Doug Warren for their assistance in the pictures of the mining machinery that changed the industry. We would also like to thank Martha McGlothlin Gayle of the United Company for her endless help through this second book on Buchanan County. The Southwest Virginia Historical and Preservation Society also must be thanked for access to its archives and expertise. Special thanks go to Karen Taylor, John Cooper, and Rita Tiller of Council High School for the trip down memory lane and the pictures that remind us all of our high school years and the people who made our time at high school memorable and helped define and shape the people we have become. Thanks go to the legendary coach Roger Rife, Scotty Wampler, and the *Virginia Mountaineer.*

We would like to thank the Buchanan County School Board and Darlene Oden, as well as Wayne Deskins, for their assistance in showing us the school system and how the schools of yesteryear have been preserved. Norfolk and Western Railroad and Rhonda Broom have continuously supported and assisted us. Sue Dotson, Vicky Jones, and Rodney Shortt have all helped, and we thank them. Special thanks go to Buchanan County sheriff Ray Foster for his assistance in showing the groundbreaking changes that the county police force has undergone in the last 70 years. Thanks to Terry Owens of the Breaks Interstate Park for showing us the beauty of a true historical treasure in the park. A special thank you goes to Earl Dotter for his permission to use the famous picture of the women coal miners, which was taken in the 1970s. This picture received national attention, appearing in numerous publications. We are extremely grateful for all the men and women who love the history and the county as much as we do. Special thanks go to Jonathan Worley of Worley Amusements, Inc., for his expertise on coin-operated machines.

Finally a special thank you goes to our editor, Elizabeth Bray, for her endless time and support during the production of this historical work.

Unless otherwise stated, all photographs are courtesy of the authors.

Introduction

As of the 2006 census, Buchanan County, Virginia, was ranked as the poorest county in the commonwealth of Virginia and one of the poorest counties in the United States. Poverty and hard times are nothing new to this county, and the people of this county have always bounced back to survive and live to play another day.

Currently, the county is in the process of reinventing itself. The old downtown has been torn down and moved. New buildings have been built, and businesses are starting to come into the area. The old industries of mining and logging are still present but are not the economic force they once were. The new industry is academics. The Appalachian School of Law and the Appalachian Pharmacy School are breathing new life into an area that was known for making coal miners millionaires three decades ago.

The history of Buchanan County starts in 1858, when it was created by Act 156 of the Virginia General Assembly. The county was named for James Buchanan, the 15th president of the United States. The county seat was named for Felix Grundy. Grundy was a congressman, U.S. senator, judge, and the attorney general in Pres. Martin Van Buren's cabinet in 1838.

The county entered the Civil War in 1861. Since few slaves lived in the area, few gave the war much thought. That changed in December 1864, when Gen. Stephen Burbridge advanced into the Cumberland Gap. The Union army advanced into Southwest Virginia, destroying towns and homes. The county survived the war and continued to prosper.

Pioneers in education, such as Helen Timmons Henderson (1877–1925), helped in the formation of the Buchanan Mission School at Council, Virginia. She and Sarah Lee Fain (1888–1962) of Norfolk became the first two women to be elected into the Virginia General Assembly. Women were instrumental in the county in breaking barriers that were once the domain of the men. Women coal miners would go into Virginia Pocahontas Mine No. 2 in the mid-1970s.

Industry arrived, as did the railroad. Both opened doors for the clannish-type citizens of the county. With the arrival of industry came work for its citizens, who had formally been farmers and miners. Schools opened, and sports teams were born, ready to play each other in a friendly, and sometimes not so friendly, competitive manner. The county takes its sports seriously. The county boasts championship wins in wrestling and basketball. Sports have served the area as a way to unify its citizens. Legendary coaches were born and raised within the county border, notably "Smiley" Ratliff and Roger Rife.

The county is most famous for the millionaire coal miners that the boom of the 1970s and 1980s created. The county also has an abundance of excellent law firms. The Street Law Firm, which specializes in mining and mineral rights law and black lung law, is ranked among the top in the state.

With the reinvention and rebuilding of the county comes a new and improved image, one of an emerging academic village with both a law school and a pharmacy school. The county also has Mountain Mission School, a legendary school that has stood since 1921. The county's oldest newspaper still records

history in the form of the *Virginia Mountaineer*. The newspaper was started in May 1922 and still records the events of the day. Other notable newspapers include the *Voice*, which is truly an appropriate name, since the citizens readily voice their opinions and stand by their convictions and beliefs.

Today the county ranks first in the state and second in the nation for its police force, which is under the leadership of Sheriff Ray Foster. The county has a reputation as a law-and-order community that has sustained it from its birth, with no tolerance for lawbreakers and outlaws. Sheriff Foster defeated Paul Crouse in the 2004 election. Crouse was the longest-serving sheriff of Buchanan County, serving from 1984 to 2004.

The new and improved county has beautiful rivers and streams, friendly people, and a bright future, with an eye to preserving its distinguished history. It has survived fires, floods, and poverty to emerge as a vibrant county that is ready to conquer and live up to the name it has often been given—the last frontier. The county and its people are full of hope and motivation to see what the future has in store.

GRUNDY

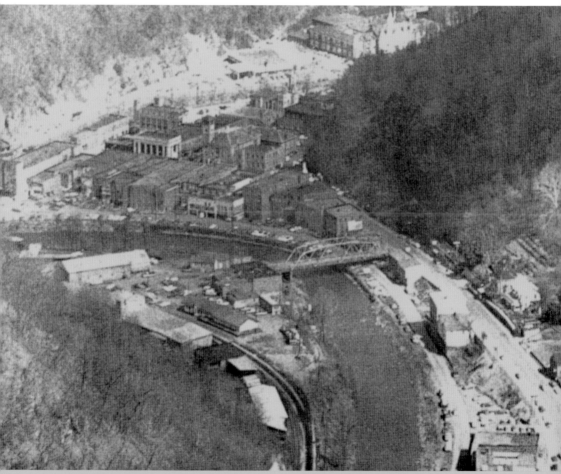

This image shows historic Grundy during the booming 1970s. Two weeks before the flood, the town was alive with plenty of stores and shopping for all. The service station was conveniently by the courthouse, and the Lynwood Theatre was open for business. Life was simple and good for the town that had not yet suffered a devastating flood and record-high poverty levels. (Image courtesy of the United Company.)

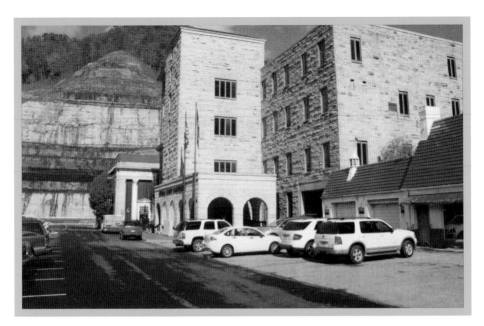

The town of Grundy has changed drastically. The buildings that once stood are no more. The road behind those buildings now has four lanes. A parking lot for court traffic stands where the Ben Franklin and Lynwood Theatre once stood. All of these changes are part of the reinventing of Grundy and are necessary to develop an economy that isn't dependant on coal and logging exclusively but instead focused on academics. (Then image courtesy of Charliece Swiney.)

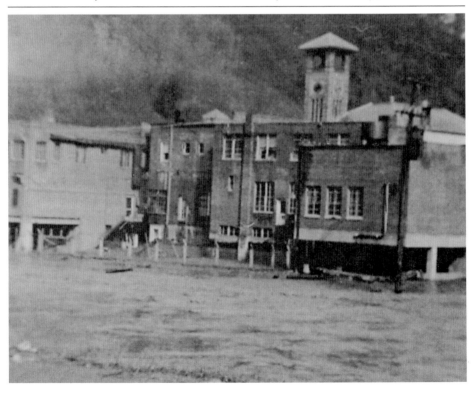

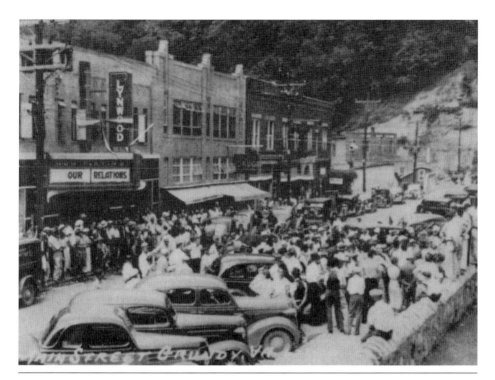

The Lynwood Theatre was the center of town activity for Grundy's young and young at heart for decades. The Lynwood had the most recent movies, and double features were available on Fridays and Saturdays for 14¢. Now the new theater is atop the parking garage, which is just a short distance from where the old Lynwood once stood. Movie tickets now cost $7.50, and the popcorn is now $5 with a drink included. (Then image courtesy of the Southwest Virginia Historical and Preservation Society.)

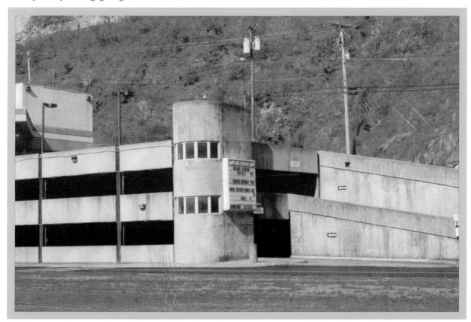

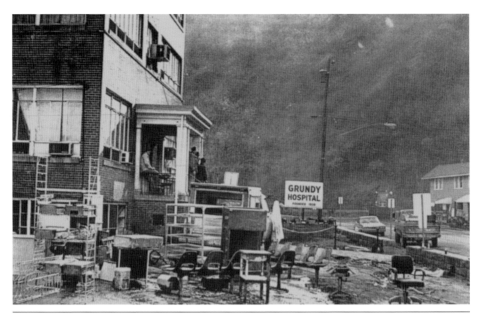

In 1911, Dr. A. S. Richards organized Grundy's first hospital in Hurley, Virginia. By 1918, ten rooms made up the Knox Creek Hospital. It was used until 1933, the year it moved to Grundy. The hospital was sold in 1937 to Dr. W. R. Williams. It was called Grundy Hospital from 1938 until 1978, at which time the new Buchanan General Hospital was built. (Then image courtesy of the United Company.)

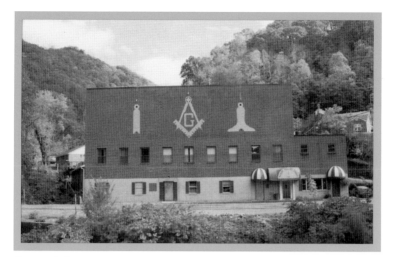

The Temple Motel, located on Slate Creek in Grundy, has stood for 60 years. The Temple Motel, along with the Anchor Inn, provided a place to sleep for out-of-town guests and a retreat for locals to escape to during floods, economic hard times, and prosperity. The motel now serves as the Sandy Valley Lodge No. 17 for the lodge members of the area. (Then image courtesy of Charliece Swiney.)

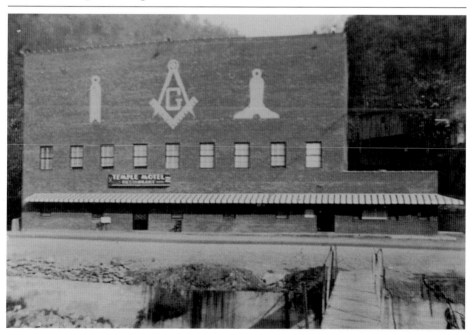

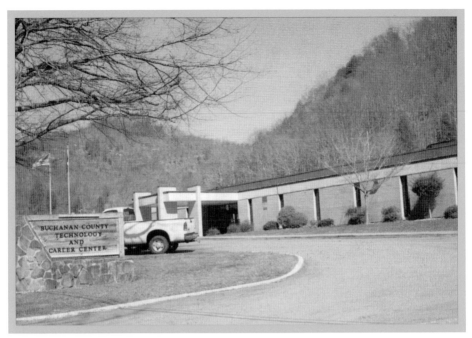

Mountain Mission Vocational Building served as the county's first school to teach locals how to perform occupational tasks, such as working on cars or cutting hair. Learning these types of skills are valuable in supporting community members. For the past 30 years, the Buchanan County Technology and Career Center, located on Slate Creek, has continued this tradition. The school still teaches students cosmetology, and now nursing is offered. The school programs are affordable for all of its students. (Then image courtesy of Charliece Swiney.)

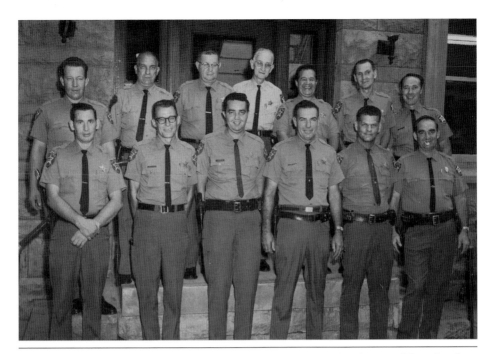

The Buchanan County police force of the 1950s consisted of 12 officers and the sheriff. The police force of today has over 30 officers, including three investigators, three K-9 officers, and several women officers. Not only are women now included in the police force, but also the size of the police force has doubled since the 1950s, which has a direct relation to the fact that the demand for protection has increased. (Then image courtesy of Bobby May, now image courtesy of Vicky Jones.)

The diners of years ago provided tabletop jukeboxes, 10¢ sodas, and meals costing less than $1, which helped make diners the place to go on a Friday night date. Since opening about 45 years ago, Dotson's Drive In has always been a popular destination for dates. It is well known for its mini burgers and homemade milk shakes. (Then image courtesy of Kenny Fannon.)

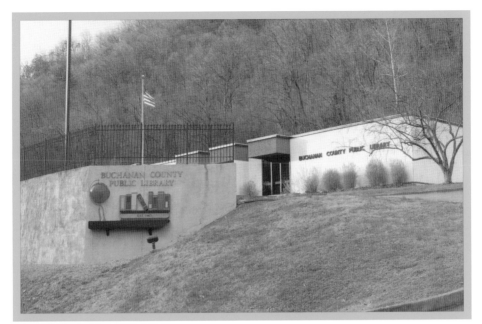

The Buchanan County Public Library was established in 1963. It is located in downtown Grundy. For many years, the library also included a bookmobile that traveled throughout the county, stopping at key locations. This was convenient for people who could not travel to the library in Grundy. The bookmobile no longer travels, but the library is still shaping the minds of the young and old.

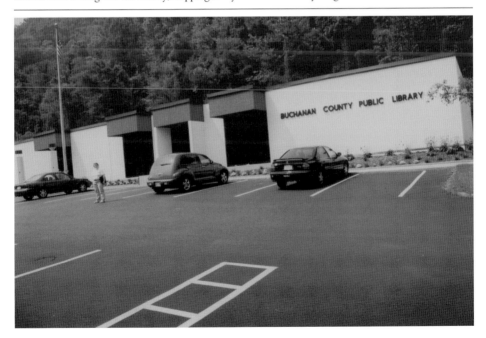

The old Virginia State Police headquarters, located in Vansant, now serves as the Buchanan County Sheriff's Department Investigative Office. The new Virginia State Police headquarters on Route 83 was built in 2006 at a cost of over $600,000.

Former Delegate Jackie Stump was instrumental in lobbying for the Department of the State Police. The state police had lobbied for years for the funding for the new building.

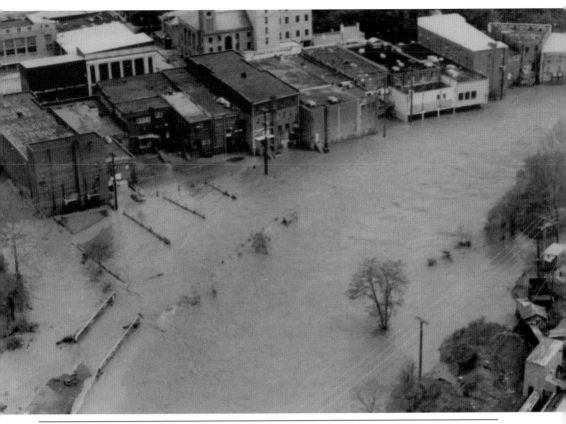

The flood that started on April 4, 1977, happened on a dreary Monday. Rainfall continued for 72 hours and accumulated over 15 inches. There were over $100 million in damages reported. Rebuilding was funded as part of the $180-million Grundy Flood Control and Development Project. For the first time in over 100 years, the town no longer faces the courthouse. (Then image courtesy of Martha McGlothlin Gayle.)

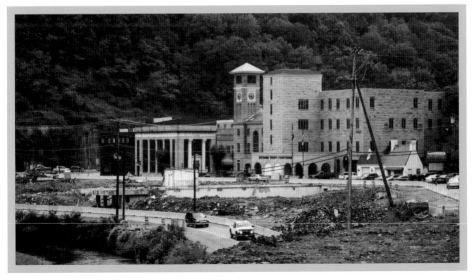

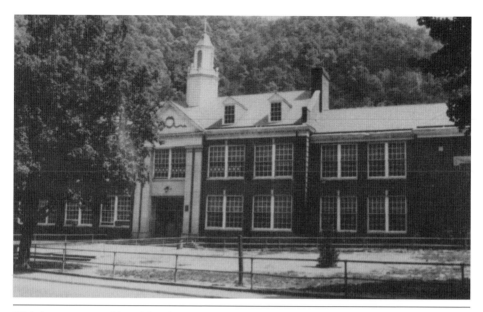

With the emergence of the public school system in the 1930s, Grundy High School was built. With the Golden Wave as the school's mascot, this high school holds the honor of having taught and coached one of the first student athletes to receive an athletic scholarship to college. The former school is now the Appalachian School of Law. Opening in 1997, the school has survived a tragic killing spree at the hands of a former student. (Then image courtesy of the Southwest Virginia Historical and Preservation Society.)

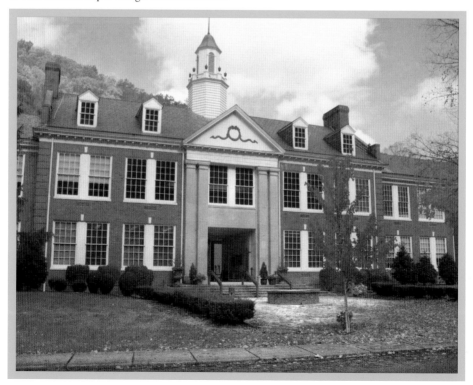

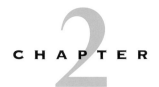

BUSINESS AND INDUSTRY

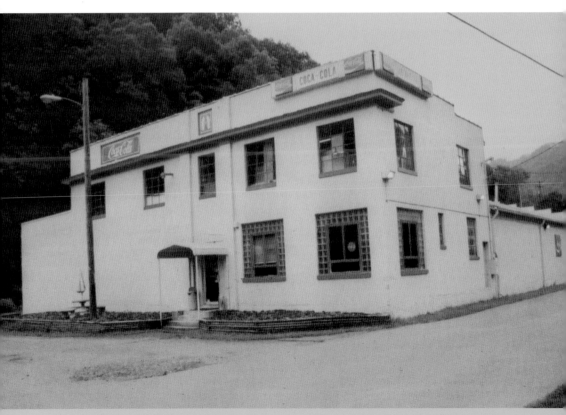

The Coca-Cola Bottling Company of Vansant, Virginia, was in business as early as 1955. This facility produced the Lonesome Pine Beverage (flavor line) that included Coca-Cola and Life, which is similar to 7-Up. By 1972, the plant ceased to bottle soda. Since the 1980s, the building has been a warehouse for Coca-Cola.

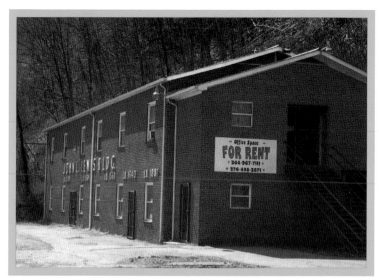

The crowds that once gathered to support the United Mine Workers are a thing of the past. Unions in Buchanan County no longer exist in a large degree. The name John L. Lewis once struck fear in the minds of coal operators. They knew he could talk the miners into striking. Now the building provides office space for rent and also serves as a meeting hall. (Then image courtesy of Charliece Swiney.)

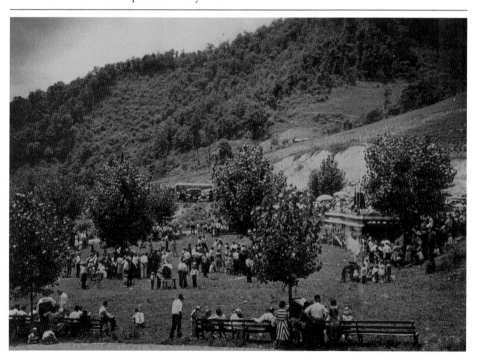

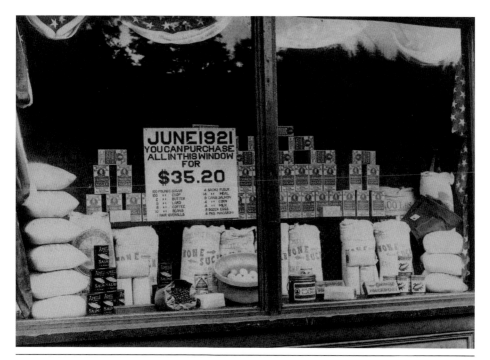

Time has changed the value of a dollar and what it will buy. Store fronts still advertise their items of the day in the window. The display of yesteryear shows that $35.20 would buy several staples necessary for running a household. The interesting thing in that window is that the price included a pair of overalls. Today one-stop shopping is still available—just at a higher cost. (Then image courtesy of Kenny Fannon.)

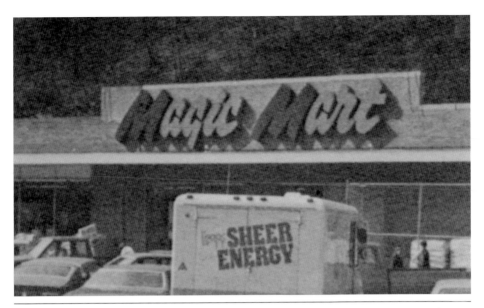

One of the few stores to survive the reinvention of Grundy is Magic Mart. The store has served the area for over three decades and is still going strong. Magic Mart serves as the only one of its kind in the county, selling "Virginia Is for Lovers" souvenirs. With Wal-Mart on its way, only time will tell if Magic Mart survives or not. (Then image courtesy of the Southwest Virginia Historical and Preservation Society.)

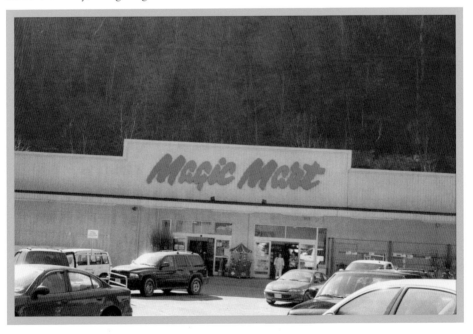

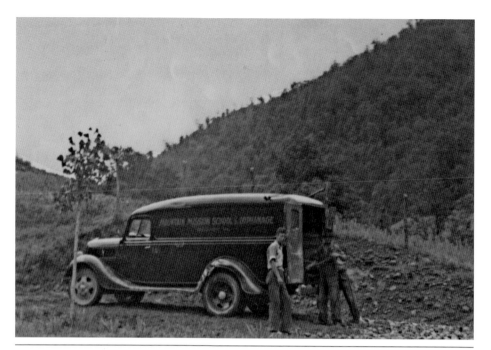

The Mountain Mission van was a rarity in the county when it first emerged. It was used in the school's many operations, ranging from farming to use at the gas station on Slate Creek. It carried food and supplies, as well as children and adults. The modern-day van is used much the same way, except it does not carry moneymaking produce. It is used to carry the academically gifted students. (Then image courtesy of Charliece Swiney.)

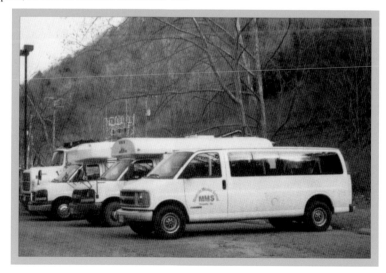

Buchanan County transit buses have thrived as a business for many years in the county. The bus of yesteryear made life easier for the families in the area. For a 10¢ fee, the bus takes passengers from Home Creek into the town of Grundy in order to shop or to take care of business at the courthouse. Current town routes are 25¢ per boarding. College students ride free. (Then image courtesy of Charliece Swiney.)

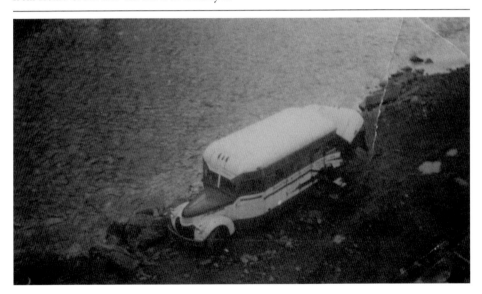

BUSINESS AND INDUSTRY

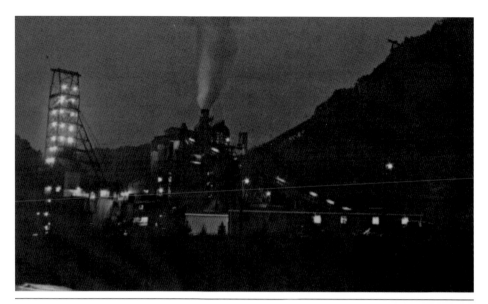

The Virginia Pocahontas Mine No. 3, known as VP3, is located at Vansant, Virginia. The mine once employed hundreds of workers producing thousands of tons of coal during the booming 1970s and 1980s. Rusting and falling apart, it now sits idle. Coal is no longer king in the county. It has been replaced with academics and other industry as the main source of jobs and incomes. (Then image courtesy of the Southwest Virginia Historical and Preservation Society.)

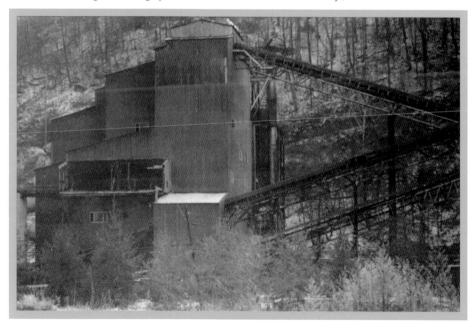

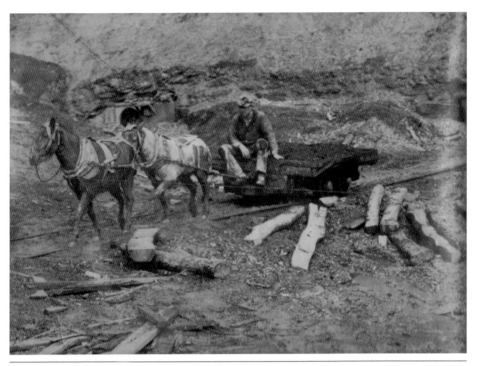

From the 1800s to mid-1900s, miners used ponies or mules to pull the loaded coal cars out of the mine. When new equipment was developed and put into the mines, the miner protested. They were afraid of losing their jobs. They believed the mine owners would not need as many men with the new equipment. Time has proven the miners correct. (Then and now images courtesy of Kenny Fannon.)

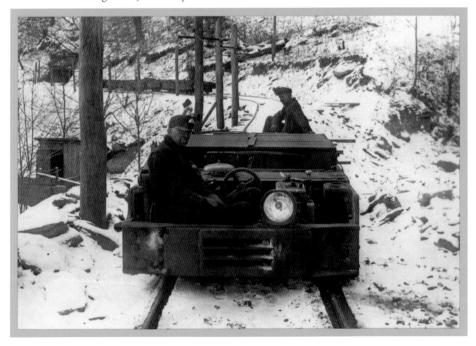

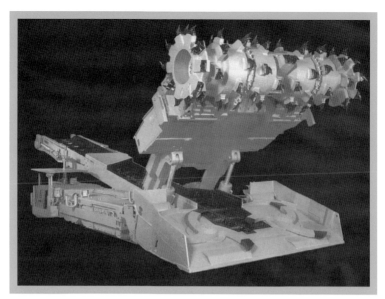

With the introduction of the cutting machine, the mine industry saw a jump in coal production. However, nothing could have prepared miners for the continuous miner. This piece of machinery is now found in most mining operations. It can cut down thousands of tons of coal in a month's time. It is a fascinating piece of machinery to watch in action. (Then image courtesy of Kenny Fannon, now image courtesy of Joy Mining Machinery.)

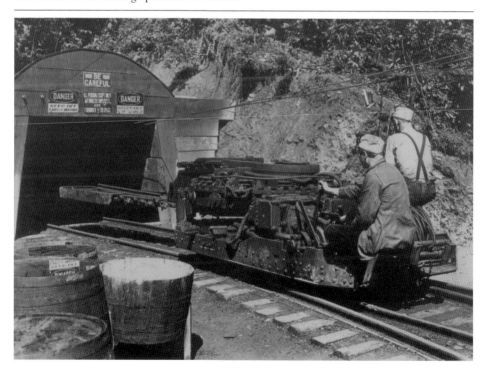

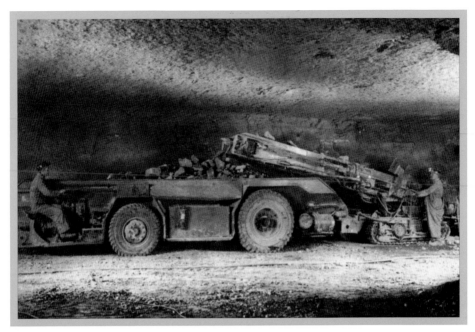

In the early mining days, a miner was paid based on the number of cars of coal he could load in a day. Before the shuttle car, many mines were nicknamed the dog hole, since the miner had to lay in mud and water in order to load the cars. In 1938, Joy Mining Machinery brought shuttle cars inside the mine. Since that time, over 16,000 shuttle cars have been sold. (Then image courtesy of Kenny Fannon, now image courtesy of Joy Mining Machinery.)

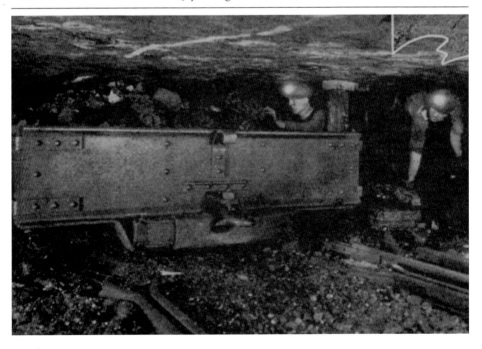

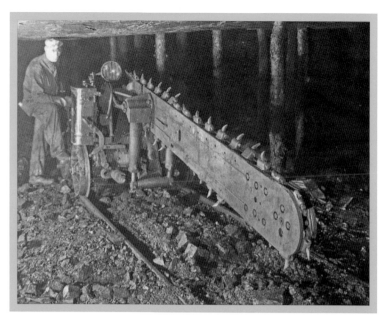

The mining of coal has always been dangerous. In the late 1800s and early 1900s, a miner had to drill the face with a hand-held auger, charge the holes with dynamite in order to shoot down the coal, and then hand-load the coal into small cars, which were pulled by ponies and mules. With the cutting machine's invention, Joy Machinery changed the way coal was mined forever. (Then image courtesy of Kenny Fannon, now image courtesy of Joy Mining Machinery.)

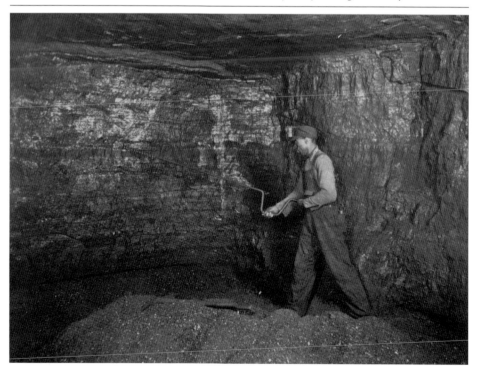

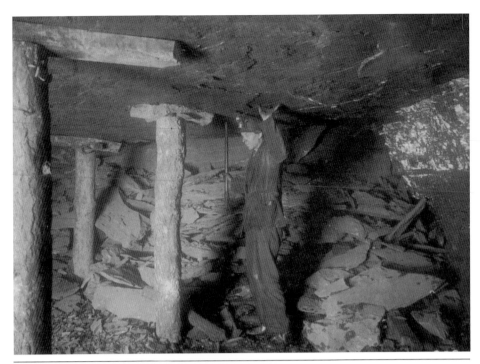

In early mining, the job of roof support was hard work, time consuming, and not very efficient. Miners had to haul logs to areas that needed support. They had to measure the logs, saw them, and then set them, leaving room for a board to go between the timber and the roof. This all changed when the Joy roof bolter arrived. After drilling the holes, a roof bolt with glue is inserted. This system is still in use today. (Then image courtesy of Kenny Fannon, now image courtesy of Joy Mining Machinery.)

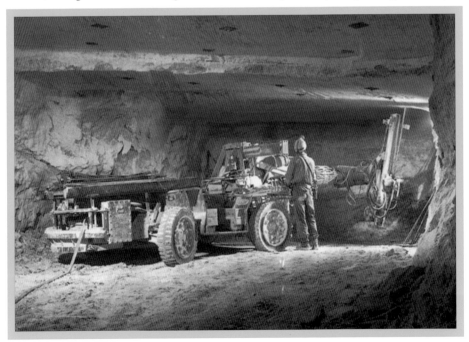

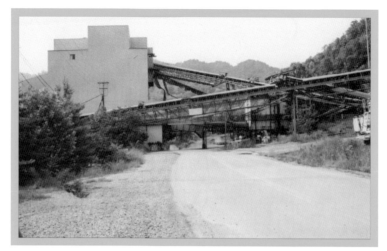

Wellmore No. 7 Preparation Plant in Big Rock was United Coal Company's first major preparation plant. The purchase of Buchanan County Coal Company gave United a rail siding and the site that would house two preparation plants, No. 7 and No. 8. The plant was completed in 1975. Buchanan County Coal Company had been United's first acquisition in 1973. United would make money off the reserves of that company for years. (Then image courtesy of Martha McGlothlin Gayle.)

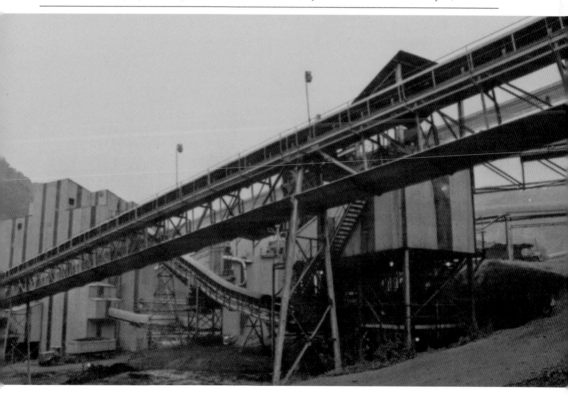

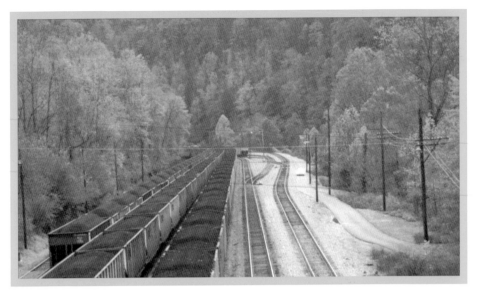

The Weller Coal Yard has changed little since the 1950s. It is located on the Levisa Fork east of Thomas, constructed as the principal assembly yard for coal trains of Buchanan County branch. The yard still carries the coal from the mountains to worldwide distribution centers. The many tracks and trains at work make for a fascinating system. (Then image courtesy of the Norfolk and Western Collection at Virginia Tech.)

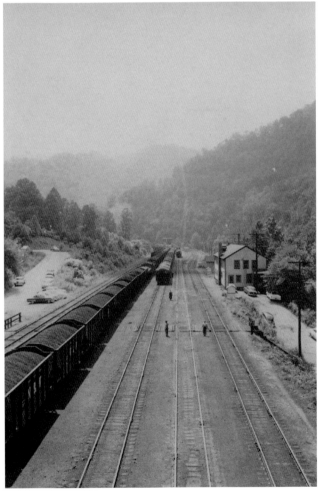

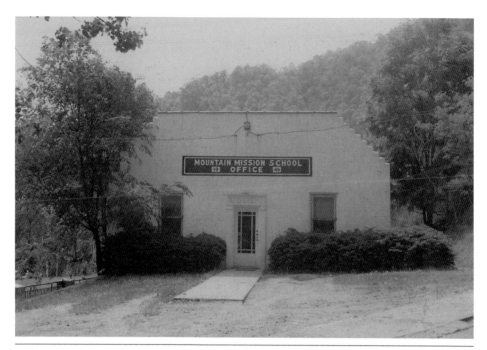

The first Mountain Mission School administrative office was on Slate Creek in the 1920s. The offices have remained there. The new offices that house the administrative staff has grown in size to accommodate the success of the school—a true legacy its founder, Sam Hurley, would be proud of. The school has served thousands of needy students as one of two private schools in Buchanan County. (Then image courtesy of Charliece Swiney.)

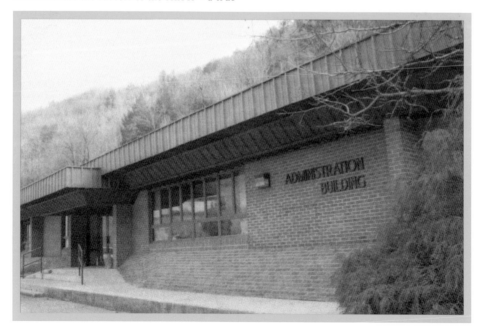

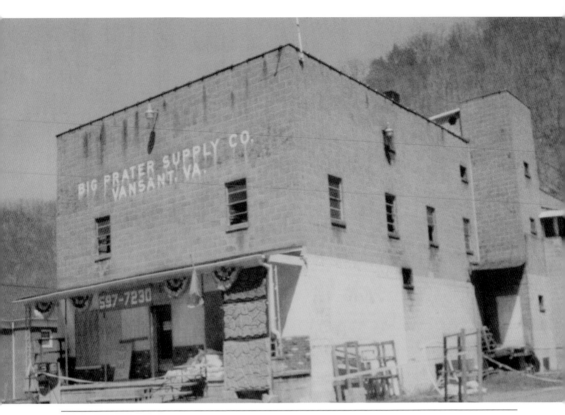

The Big Prater Supply Store and the Vansant Lumber Company have served as the county's premiere supply stores for over 60 years in one capacity or another. They have survived floods and lulls in business to continue to provide the products citizens need. Within a few miles of each other, they are often viewed as the old and the new.

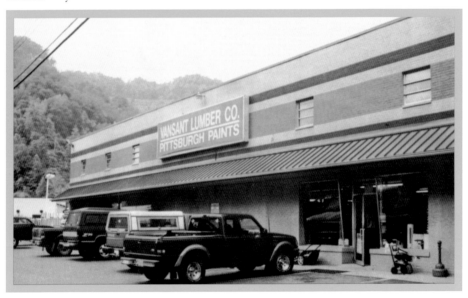

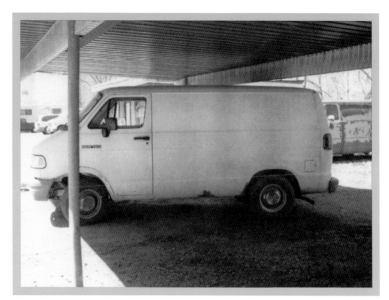

Grundy Dry Cleaners has been around a long time. The original truck was used to go door-to-door to pick up dry cleaning. Bills could be paid monthly, and the dry cleaning was returned only on a certain day. Now the new truck is used to take the dry cleaning to Bluefield, where it is cleaned and then later returned. Today bills must be paid in advance.

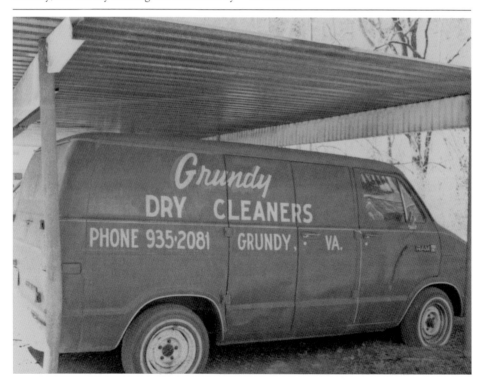

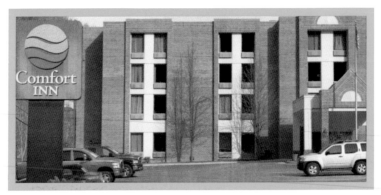

The Anchor Inn is a landmark. Built by Smiley Ratliff, it, along with the Temple Motel, was one of the few places to stay for years. In old advertisements, it stated that the motel offered television, phones, and air-conditioning. Now the Comfort Inn advertises free Internet connection, as well as the necessities of air-conditioning, telephones, and HBO. The needs of the consumer in what is considered luxury or necessity have definitely changed.

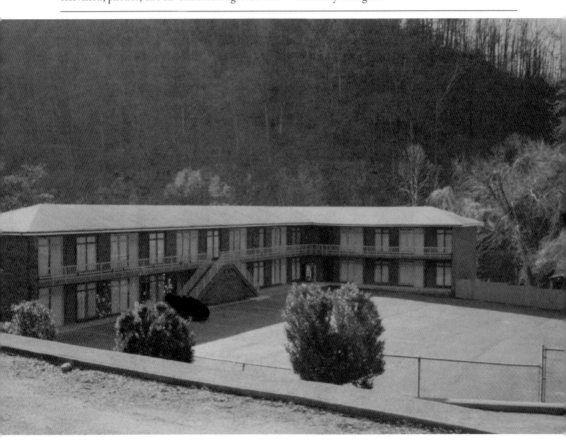

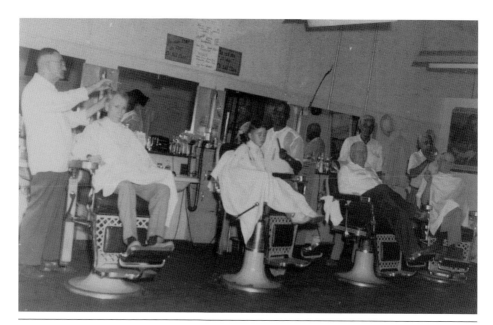

The barbershops, as they were known, have been replaced. In the 1960s, red, white, and blue poles, located outside, identified barbershops. These were places for men and boys to get a shave and haircut. Boys attending school could not have long hair. Times have changed, but the barbershop that was started by Jerry Raines is still in business after 44 years. (Then image courtesy of Kenny Fannon.)

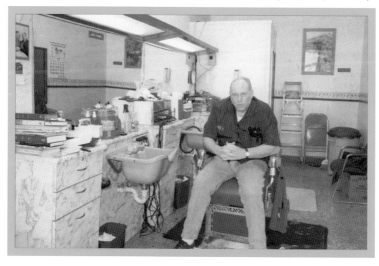

The mail carriers of yesteryear once hauled mail in their trucks from one local post office to another. Lots of times, the mail ended up in the creek, as it fell out when the truck went around the curve. Today more federal laws regulate the mail industry and their carriers. Carriers can use their vehicles, but no one else is allowed in these vehicles. (Then image courtesy of Kenny Fannon.)

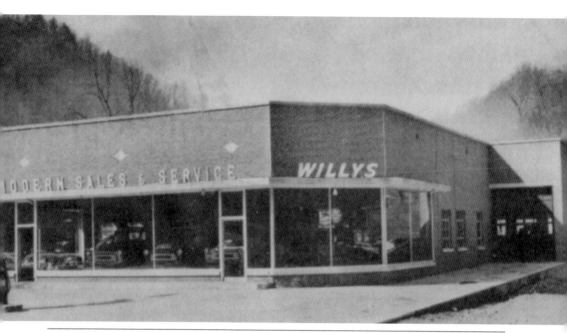

Willys Modern Sales and Services once served the area residents for all their vehicle needs, from a new car to tires and oil changes. That is not the case today, since area car dealerships are mostly smaller. Much of this change is a result of the expansion of the small-time car dealer. (Then image courtesy of the Southwest Virginia Historical and Preservation Society.)

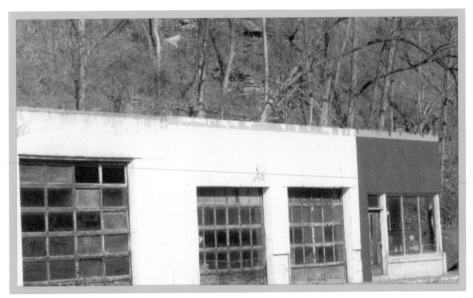

The service stations that were once found every mile or so in downtown Grundy, Harmon, and surrounding areas are no more. When coal was king, demand was high, and gasoline was plentiful. Even during the gas shortage, the gas stations stayed open. Many of the stations that once made money are abandoned, as the industries that once dominated the county have changed. (Then image courtesy of Martha McGlothlin Gayle.)

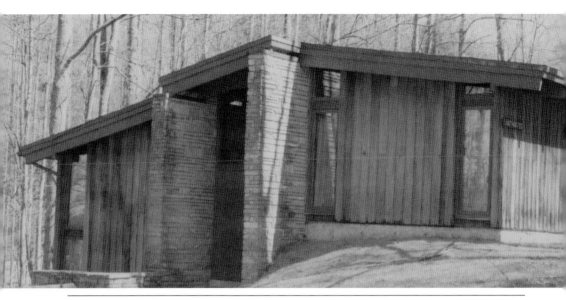

The "Grand Canyon of the South" is a must-visit for anyone who likes the outdoors. The Breaks Interstate Park is a tourist attraction that offers two-bedroom cottages that are nestled on the fringe, near Beaver Pond. The luxury cabins have three bedrooms with stone fireplaces and flatscreen televisions. The best part about these cabins is that they are located near Laurel Lake.

B&L Furniture and Appliance Company, Inc., is one of the oldest businesses in the county that still exists. Sam Bein Horn opened the store in 1936. The store carries all of the major name brands, including LG, Maytag, and Panasonic. Sam Bein Horn died in 2002, and George B. Yates purchased the company. He had worked with Horn for many years prior.

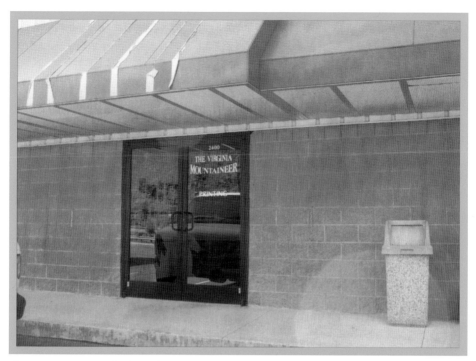

The *Virginia Mountaineer* has been a family newspaper since 1922. It began publication on May 22, 1922, when Hannibal C. Compton and Cecil C. Waldron established the newspaper. The Waldron family ran the paper until they sold it in 1951. In 1972, Lodge Compton took over the paper. The newspaper has had only token competition over the years. The newspaper has moved to the Grundy Plaza. (Then image courtesy of Martha McGlothlin Gayle.)

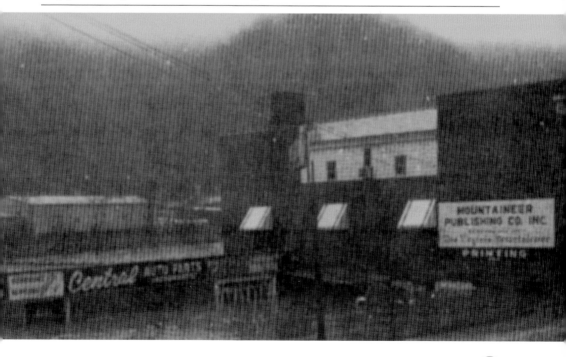

The Anchorage Shopping Center, which once served as one of the few shopping centers in the county, still serves its loyal customers. The stores have changed, but the location is still the same. The road leading to the shopping center now has four lanes, and the Anchorage has the Grundy Plaza as competition. Smiley Ratliff, the coal baron who built the Anchor Motel and who was a legendary football coach, built the center. (Then image courtesy of the Southwest Virginia Historical and Preservation Society.)

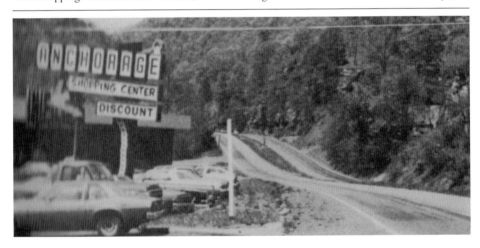

BUSINESS AND INDUSTRY

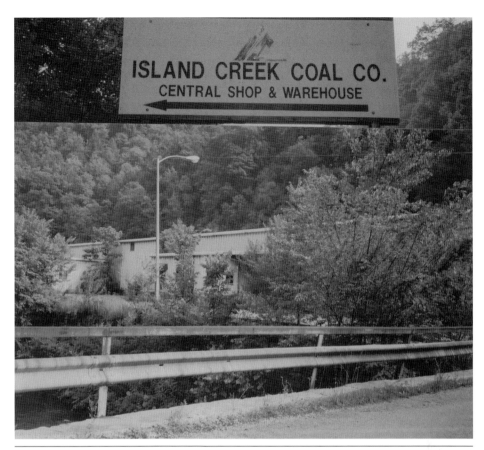

The days when coal was king have passed. The Island Creek Coal Company Central Shop and Warehouse stood empty for years. When the office was taken over by Consol, Island Creek finally pulled its operations out of the county. Consol has cleaned up the office and added its own company emblem of a red and white "C" to the outside. Gone are the red, white, and blue colors of Island Creek.

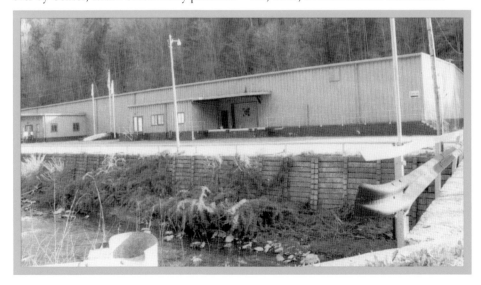

Soda and the packaging of it has been around for several decades. The type of packaging has changed. The "marble bottle" is wrongly called that, because it is actually a "pig bottle" with an internal marble stopper. The bottle was filled upside down, and the marble would then fall against a rubber ring inside of the lip. The bottle was turned right side up, and the gas held the marble in place. It was a one-trip container.

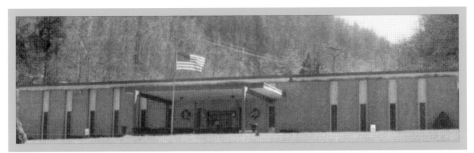

The Buchanan County Funeral Home, located at Keen Mountain, Virginia, has been caring for the families of the departed through the decades. The Buchanan Funeral Home, the Grundy Funeral Home, and the Virginia Funeral Home serve the county and surrounding areas. These three have been the dominant funeral homes in the county for the past several decades.

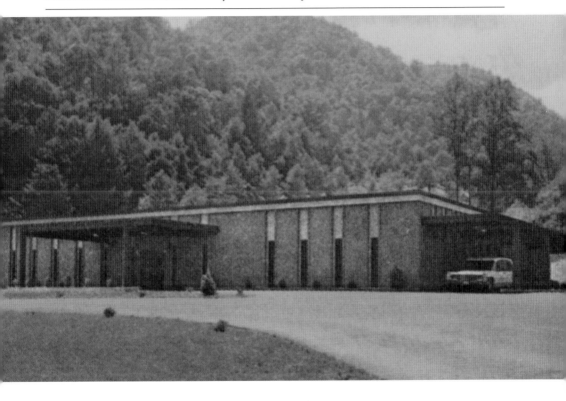

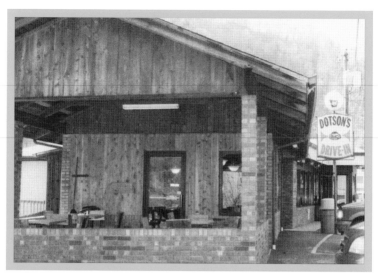

The Rainbow Drive Restaurant in Vansant is famous for home-cooked meals and homemade pies. It is open seven days a week. The Dotson Drive In was established in 1967 and is famous for its mini burgers and homemade milk shakes. It employs between 10 and 19 people. Both landmark restaurants, one served the people of Vansant the other served the people of Grundy.

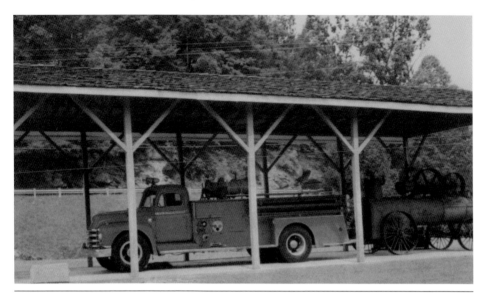

The Grundy Fire Department was established in 1947. Located in the Appalachian Mountains in Grundy, Virginia, the department serves most of Buchanan County. The department is composed approximately of 30 volunteers. With a chief, seven officers, two assistant chiefs, two captains, and three lieutenants, the fire department responds to many different fire and rescue situations, including motor vehicle accidents. They affectionately call their fire truck "Big Bessy."

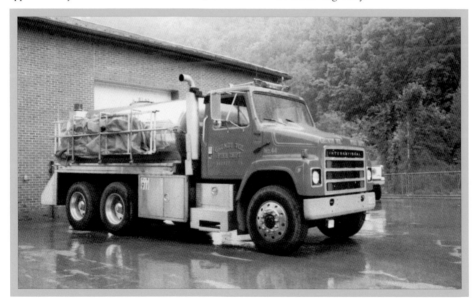

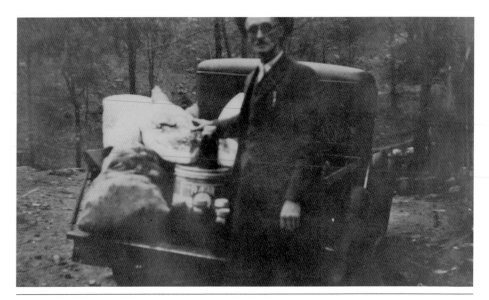

Mountain Mission School kept its doors open in the early days by generous contributions. Today the historic school is the beneficiary of a golf tournament at the Olde Farm Golf Course, which was held on June 8, 2010. Legendary players Jack Nicklaus, Arnold Palmer, and Gary Player participated in the 2010 golf tournament. The tournament was hosted at the eighth-ranked golf course in the nation. Olde Farm's clubhouse was modeled after Castle Hill. (Then image courtesy of Charliece Swiney.)

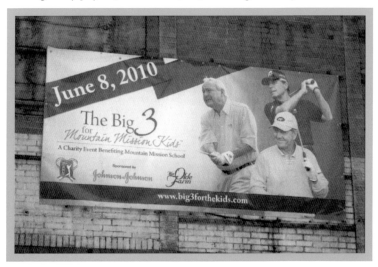

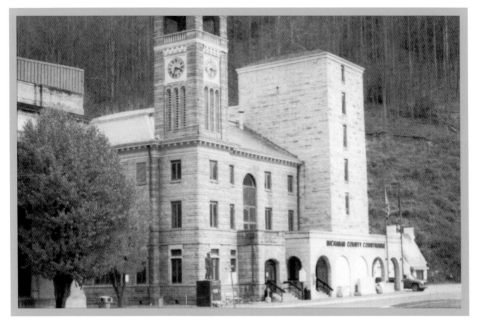

The 1977 flood devastated the town of Grundy. The United Coal Company loaned out men and machinery to clean up the town. After $100 million in damage, the United Coal Company also took financial responsibility of paying the wages for the men and women cleaning up the town. The decision to move the town was based on the flooding problems. Now downtown consists of the landmark courthouse. (Then image courtesy of Martha McGlothlin Gayle.)

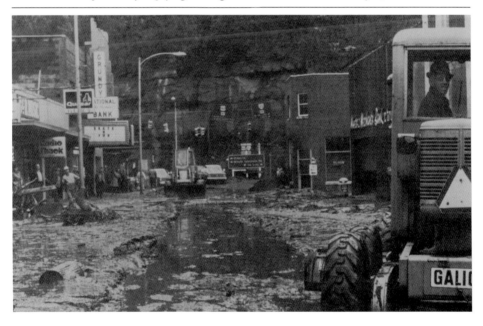

The Big Sandy and Cumberland train was a mixed train carrying both freight and passengers. The train would pass through Kentucky and stop at Hurley, Virginia, with an arrival time of 11:55 a.m. at Grundy. It would then depart from Grundy on the Levisa Fork and return to Devon, West Virginia. Trains are still popular but only as tourist attractions today, whereas they were a means of transportation in years past. (Then and now images courtesy of Kenny Fannon.)

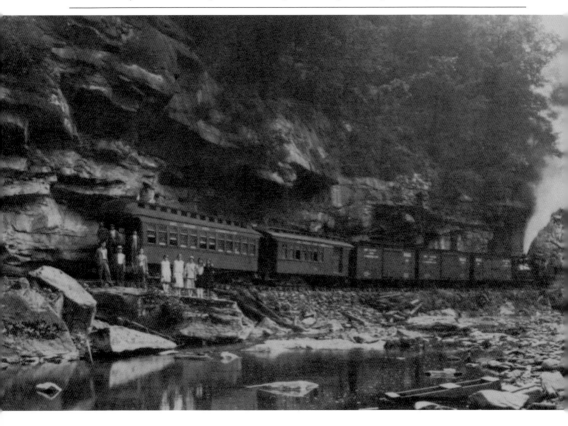

United Coal Company started out with seven original partners who bought one mining company. The company grew to become the largest employer in Buchanan County. Its growth forced it to expand, and part of that expansion included moving the company headquarters from a small office in Grundy to Sullins Academy in Bristol, Virginia. The growth of the company made all the original partners millionaires several times over. (Then and now images courtesy of Martha McGlothlin Gayle.)

Nothing is more symbolic of Buchanan County than the landmark courthouse. The building has survived over 100 years. The industry of judicial business is one of the county's biggest employers, which includes the employment of the police force, deputies, investigators, sheriff, lawyers, judges, and the support staff of clerks, secretaries, and assistants. The county now has a law school that is training more lawyers. (Then image courtesy of Charliece Swiney.)

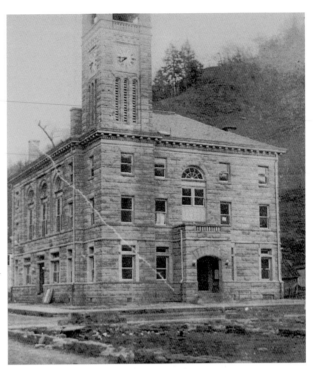

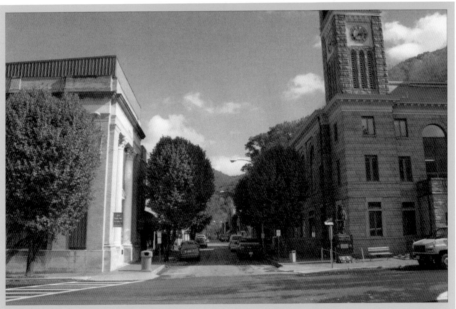

CHAPTER

3

SURROUNDING AREAS

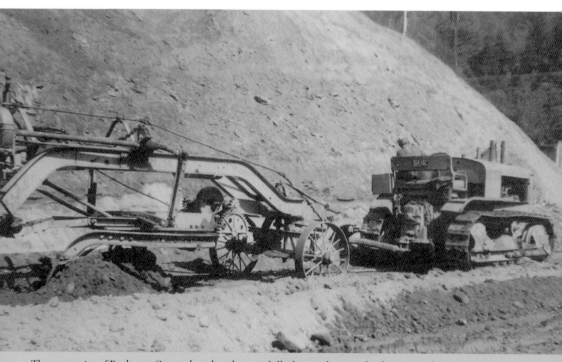

The mountains of Buchanan County have long been considered some of the most scenic in the state. However, in order to build homes and businesses, much work has been required over the centuries. From digging out small roads to removing an entire hillside to make room for the town and surrounding buildings, man and machine have long been partners in the endeavor to build a life for the people of the area. (Image courtesy of Charliece Swiney.)

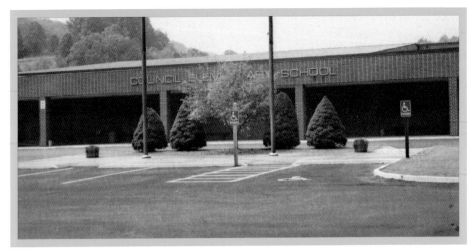

The Buchanan Mission School began its first session under Mr. and Mrs. Henderson in August 1911. Children from the neighborhood attended. Several children boarded at the dormitory. No compulsory school law existed at that time. With a vision beyond her years, Helen Henderson was the driving force at the school. Since 1983, a new school, Council Elementary, has been located within sight of the old mission school. (Then image courtesy of Council High School.)

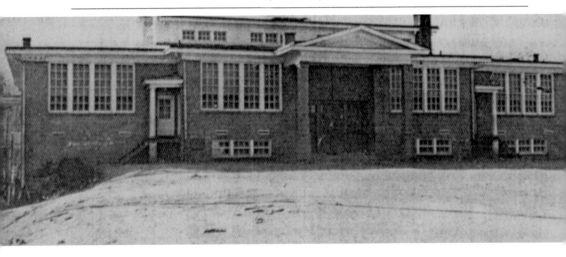

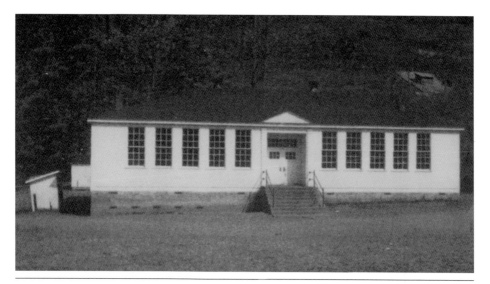

The original Street School was located across the road, where the church stands now. In 1934, the four-room school was built across the road. The 75-by-46-foot structure was where children were taught until it was consolidated with Garden. Wayne Deskins was the head teacher at the time of the closing. The consolidation closed 30 to 40 small historic schools. (Then image courtesy of Buchanan County School Board.)

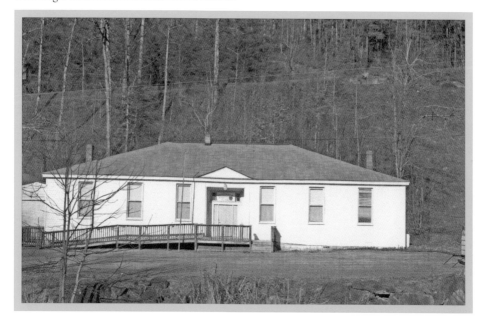

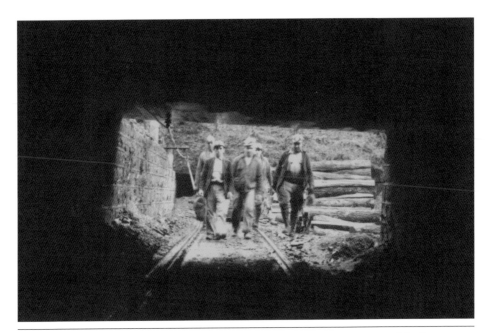

The days of men exclusively in the mines were numbered. By the 1970s, women were starting to see the financial advantages of going into the mines to provide for their families, just as the men had done for years. Printed in publications across the county, the picture of the four women miners was seen as a sign of the changing times. (Then image courtesy of the Norfolk and Western Collection at Virginia Tech, now image courtesy of Earl Dotter.)

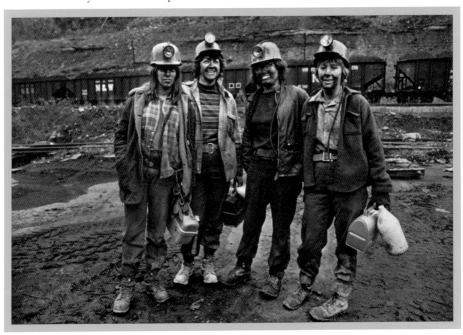

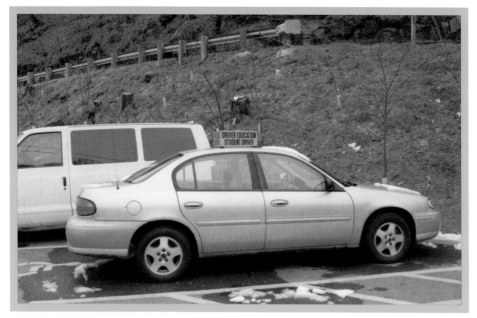

By 1967, Council High School, like many schools, was participating in the driver education program. As early as 1906, Virginia had recognized the need for safe drivers when the state started requiring licenses and registrations for the first motor vehicles. Today schools across Virginia still require a comprehensive driver education program for their students to help them develop safe driving habits. (Then image courtesy of Council High School.)

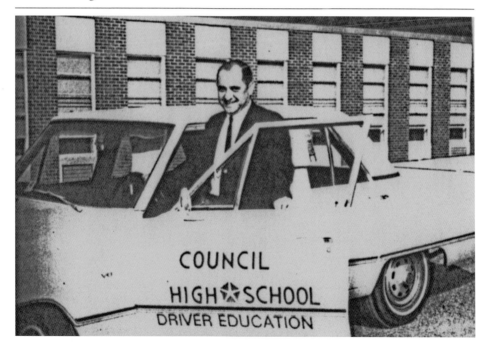

Founded by the Methodist Church, Garden High School at Oakwood, Virginia, began in the 1920s and was established as the Triangular Mountain Mission (TMI). The school operated as a private school from the 1920s until 1936. During the Depression, the church asked the county to take it over. It went public in 1936. In 2001, it disappeared with the school consolidation plan. (Then image courtesy of the Norfolk and Western Collection at Virginia Tech.)

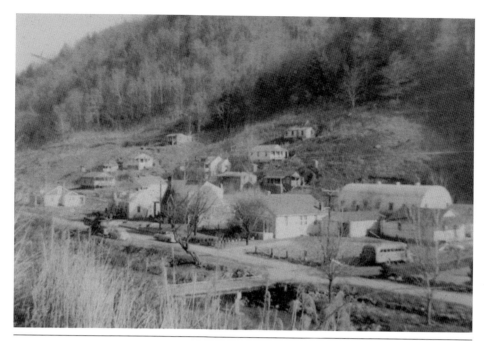

Early Slate Creek residents survived by farming and coal mining. Usually, the husband would work 10- to 12-hour shifts at the mine. The wife would stay at home raising the children, tending the farm, and maintaining the home. Today many of the residents work at the law school, school of pharmacy, or other academic professions. However, many still farm and work in the mines in order to support their families. (Then image courtesy of Charliece Swiney.)

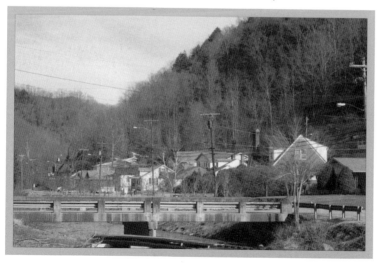

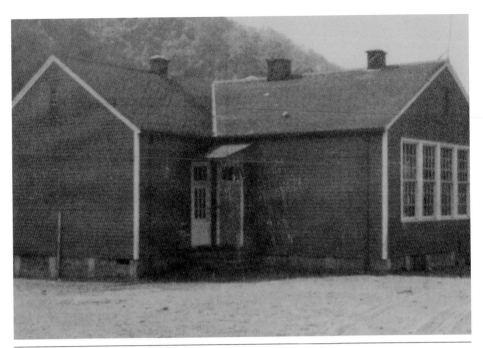

The Home Creek School that many school children attended from 1941 to 1969 is now a playground. Louise Clevinger was the head teacher in 1969, when the school closed for good. The historic school was torn down to make room for the playground, so it is still serving the children of the community. The historic calendars of the schools of yesteryear are the only surviving items. (Then image courtesy of the Buchanan County School Board.)

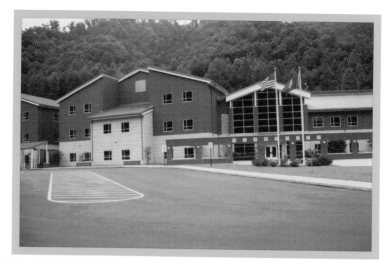

The old Big Rock School has been torn down, and students now go to New Riverview. The school consolidation program of 2001–2002 combined the elementary schools of Big Rock, Harmon, Grundy, and Vansant into New Riverview. The school consolidation plan was a cost-saving measure to address the issues of decreasing student numbers and increasing expenses for the county school system.

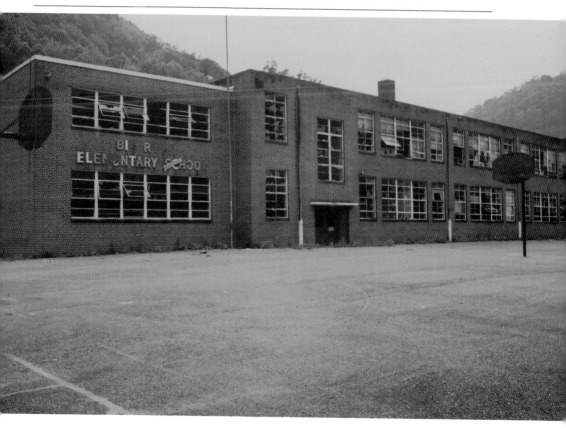

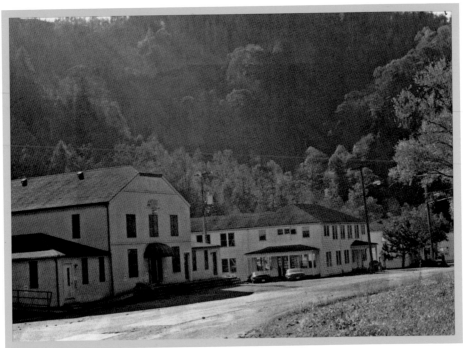

Shown here is the Keen Mountain Camp around the 1940s. These houses were for company officials. The miners' houses were usually more basic, with two or three bedrooms. The miners paid for the residences by working in the company mines. If they quit or were fired, they had to immediately vacate the property. The private residences have retained the basic design that is readily recognized by historians. (Then image courtesy of the Norfolk and Western Collection at Virginia Tech.)

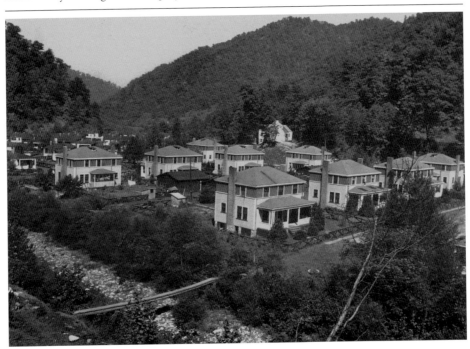

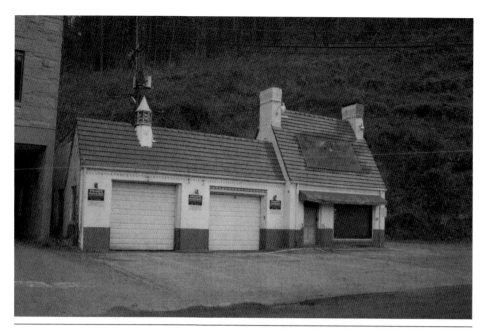

The service station by the courthouse is one of the oldest landmark buildings still standing in Buchanan County. It is no longer a service station but a symbol of bygone times. Service stations now provide a wide variety of products at the cheapest price possible to their consumers. The days of being loyal to one brand and one provider are gone. Now it is all about the cost to the consumer at service stations.

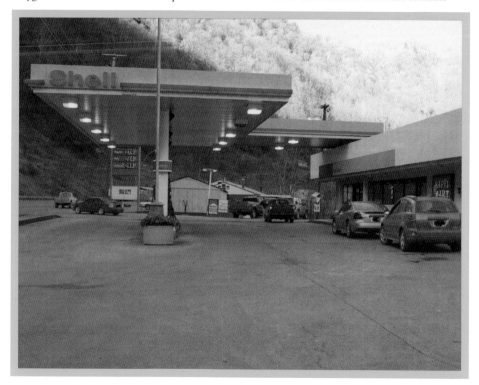

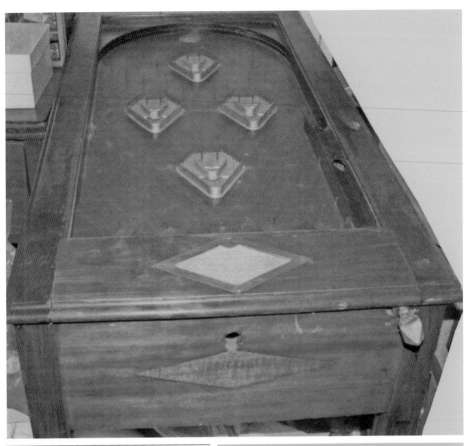

The games played in the 1930s and those played in the present day have changed. In 1932, the In and Outdoor Company of Chicago built the Spot Ball. According to experts, the Spot Ball game pictured above was a salesman's sample that he would take around to show to potential customers. Today the pinball machine has all the bells and whistles. Only Stern Manufacturing in the United States produces the pinball games. (Now image courtesy of Worley Amusements, Inc.)

CHAPTER 4

PEOPLE AND EVENTS

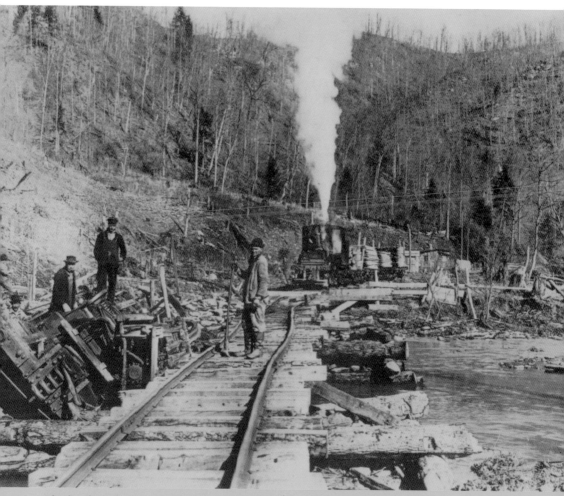

The derailing of a train was a major event in early Buchanan history. The method of moving men, machines, and supplies could be held up for days, costing the company a great deal of money. Ritter Lumber Company didn't like losing money or profits. (Image courtesy of the Southwest Virginia Historical and Preservation Society.)

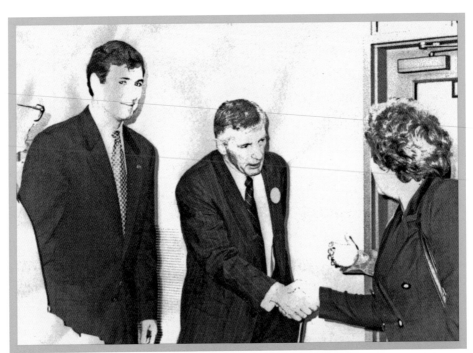

Coach Roger Rife of Garden High School was a legendary coach for the county and in Southwest Virginia. A great motivator, he had a brilliant mind for basketball, making him the logical person to head the Garden football program in 1986. Rife coached many winning teams as a Garden coach. Rife has gone on to participate in county politics, which includes being a guest at the Virginia governor's lecture series. (Then image courtesy of Roger Rife.)

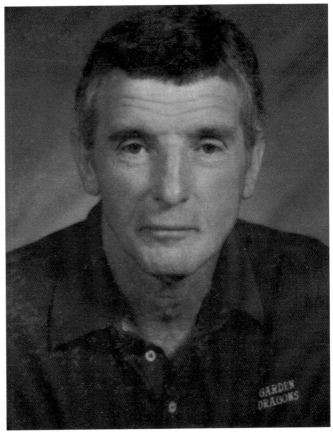

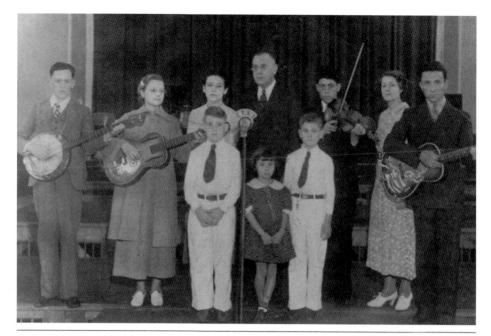

Bands and radio shows once served as the primary form of entertainment for the locals. People who attended these performances were often the friends of those in the band. Several local musicians that would later become famous started out playing at community dances. Consisting still of locals, bands put on shows now mainly for county fund-raisers instead of for purely entertainment reasons. (Then image courtesy of Charliece Swiney, now image courtesy of Vicky Jones.)

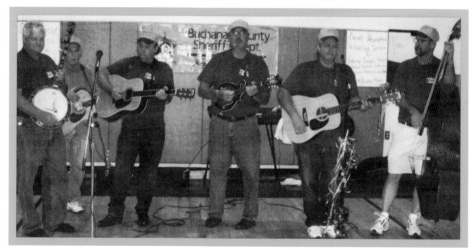

G. R. Bird served as the principal at Council High School in the 1960s, when the school's yearbook was known as the *Hilltop View*. Now Karen S. Taylor is the principal of the school. The school's mascot is a cobra, and the yearbook is called *Highlights*. Council is one of four high schools in the county. The other three are Hurley, Grundy, and Twin Valley. (Then image courtesy of Council High School.)

Here is a political candidate advertisement depicting Sam Hurley running for the Ninth Congressional District in 1926. "Bad Sam," as he was known, made political enemies to the point that a bounty was placed on his head. But races in the "Fighting Ninth" have always been heated. The 1900 race between Gen. James Walker and Judge William Rhea resulted in shots being fired. In 1981, Rick Boucher ran an equally heated race against Bill Wampler. (Then image courtesy of Charliece Swiney.)

FOR CONGRESS

SAM R. HURLEY

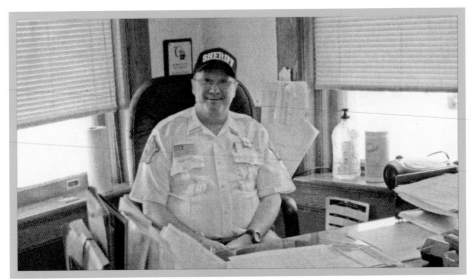

The people of Buchanan County have chosen their sheriffs well. In 1984, they elected Paul Crouse. Crouse held the record for longest serving sheriff in the county when he left office in 2004. Having served two decades, he was defeated by Ray Foster. Foster has updated the sheriff's department. He brought state and national recognition for the department by winning awards and cracking down on crime in a way unknown to the area. (Then image courtesy of the United Company.)

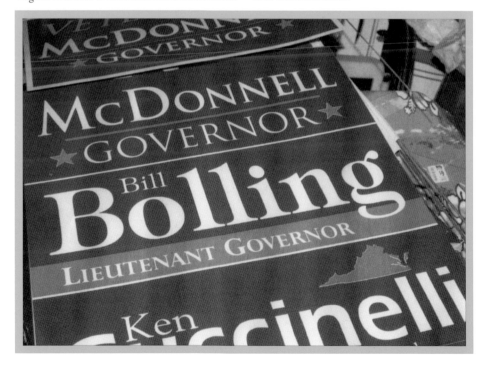

In Southwest Virginia, campaigning for elective office has changed little. Store owners and residents still place political signs in front of their businesses and on their lawns to show support. Virginia went blue or Democrat in the race between Barack Obama and John McCain, an occurrence that had not happened since the days of Lyndon B. Johnson. The area and state usually remains conservative in their beliefs and demand that of their elected officials.

Family and sports are held in high regard in the county. Everyone knows everyone else, and families go to ball games together. They compete against each other during the week and then go to church together on Sunday. The values that made this country great are still practiced on a daily basis. The concept of a stranger is unknown. Everyone speaks and offers a helping hand to his or her neighbor. (Then and now images courtesy of Roger Rife.)

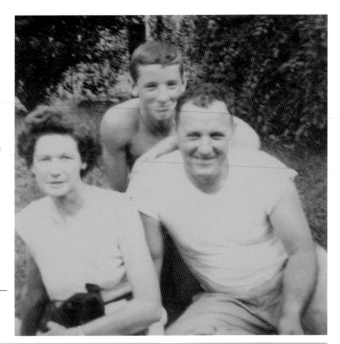

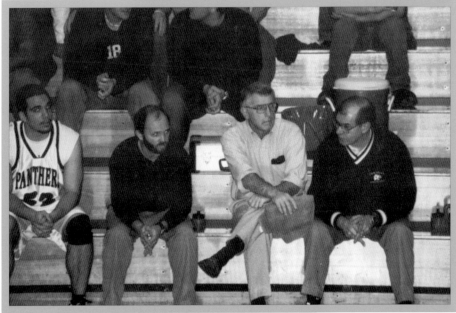

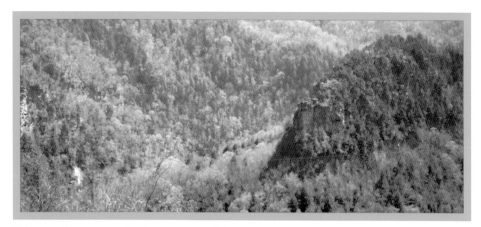

Hiking and mountain climbing are two of the major reasons that people visit the Breaks Interstate Park, or the "Grand Canyon of the South" as it is known. The geological trail is one of the most popular sites at the park, going hand in hand with the hiking and biking trails. The climbing area is recommended for experienced climbers, as some of the formations are not for amateur climbers. This park is a must-see. (Then and now images courtesy of Terry Owens.)

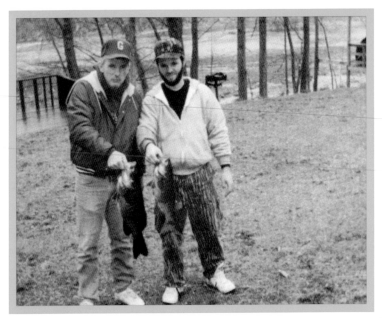

The county still has many of the old forms of entertainment and amusement, hunting and fishing being among the sports that people enjoy the most. Both hunting and fishing were once means to feed a person's family. Now both sports are included in some of the ways the men and women of the area have fun. Many people are starting to see the area as a tourist area for the hunting and fishing. (Then and now images courtesy of Roger Rife.)

PEOPLE AND EVENTS

The town has preserved its churches despite the reinvention of the county and the rebuilding of the town. The churches are packed to capacity on Wednesday nights and Sunday mornings. They are places for spiritual guidance, weddings, christenings, and funerals, which all define life. The churches that were built a hundred years ago still stand as a testament to the stability of life. Despite changes, these churches still remain.

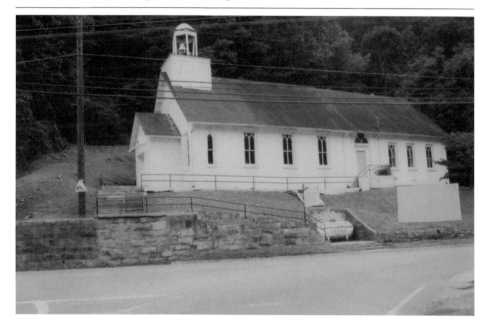

The children of the county still love to play outdoors. With swing sets in backyards or at the park, playing has changed little in the past 80 years. Children still love to be outdoors with their friends, and millions of parents still buy the required swing sets. Many today take their children to the park as a way to meet up with friends and family. Many go on Sundays for birthday parties.

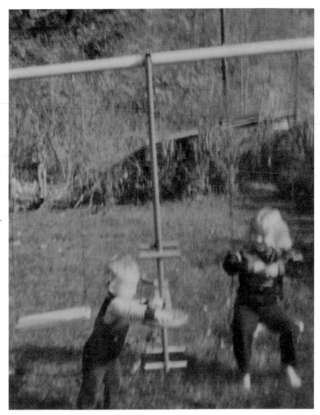

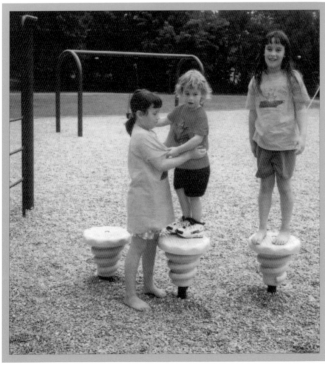

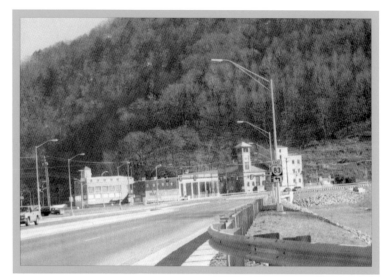

The rebuilding of the town has become a major event for the citizens of Grundy and the county. The old is out and has been replaced with a new and modernized town that is open for business. For the town and for new businesses looking to come into the area, Wal-Mart will be arriving in the area in the near future. (Then image courtesy of Charliece Swiney.)

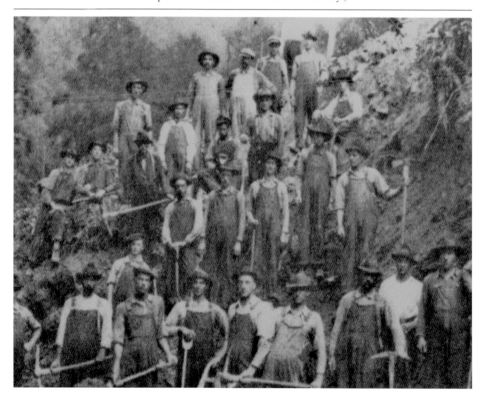

The job of being a deputy in Buchanan County was predominately a job for the men until recently. Much has changed in law enforcement since the 1940s. The county now has a new sheriff who has been recognized for his numerous years of dedication to the law and to the people. (Then image courtesy of Bobby May, now image courtesy of Vicky Jones.)

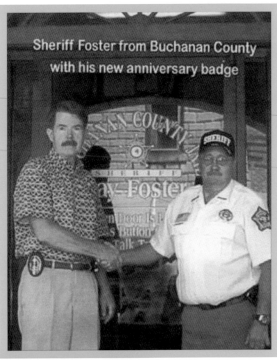

Sheriff Foster from Buchanan County with his new anniversary badge

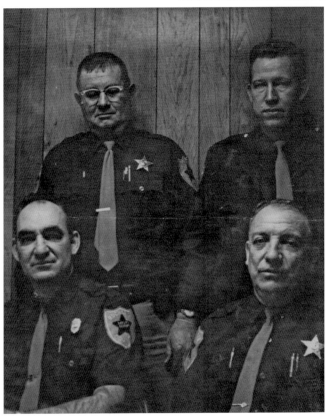

The young men of the county have often answered the call to serve the country and to uphold the values they were taught in small-town life, the values of country and family. Many have answered that call, leaving behind girlfriends or wives, only to anxiously return every leave to those they are fighting for. They often return after years of services to the place they call home. (Then image courtesy of Charliece Swiney.)

County Fourth of July celebrations have not changed. They are still characterized by family, friends, fireworks, and food. The celebrations that take place still bring the community together. Everyone enjoys the rides, music, and fireworks, and the food is always plentiful. (Then image courtesy of Charliece Swiney, now image courtesy of the *Virginia Mountaineer*.)

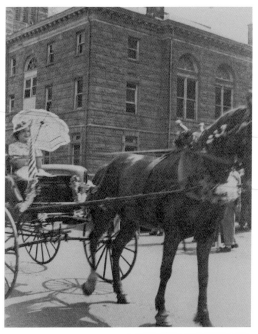

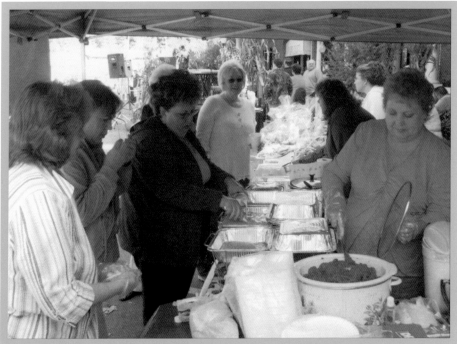

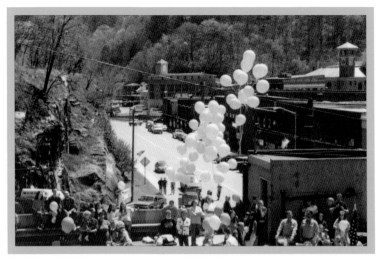

Along with the rest of the country, the innocence of small-town life has changed. However, the county pulls together to help underprivileged children by placing them in good homes and teaching them the core values. By taking these children to town events where yellow balloons are let loose to celebrate military pride, they are taught to appreciate the sacrifices that the men and women in the military make for the sake of the country. (Then image courtesy of Charliece Swiney, now image courtesy of Vicky Jones.)

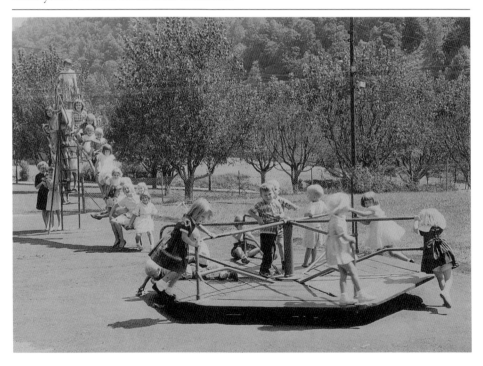

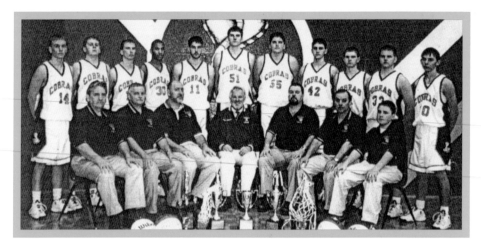

Council High School's boys basketball team has a long and distinguished history. With legendary coaches, such as David Rasnake and Willie Sullivan, the school became the 2001 state basketball champions. Its history of excellence on and off the court has made Council a school to watch on a state level. The school has been wise in its choices of coaches. (Then and now images courtesy of Council High School.)

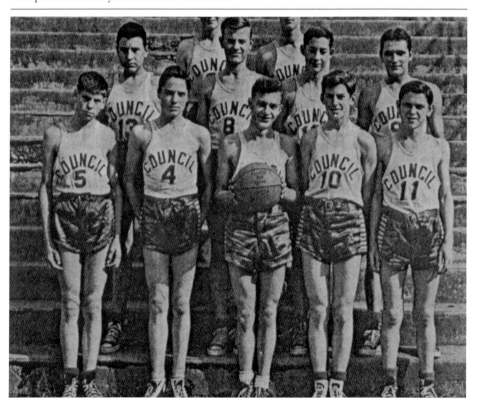

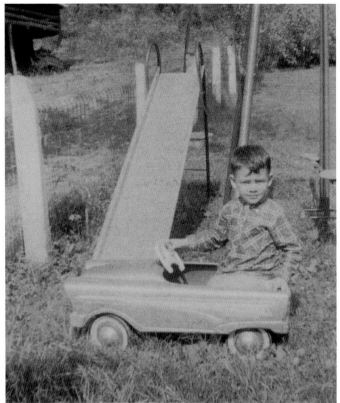

In the 1950s and 1960s, the must-have toy was the pedal car. Today the must-have toy that most parents purchase for their children to ride is the Power Wheels. A battery runs the Power Wheels, whereas the pedal car was run by manpower. (Then image courtesy of Bobby May.)

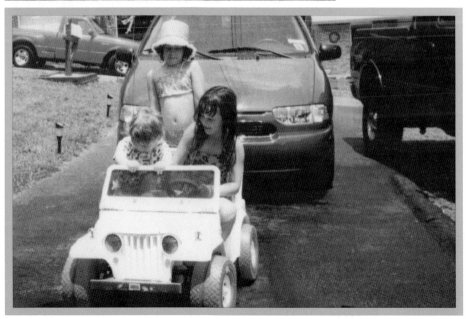

Coal is still king in the hearts of the people of the county. The statue at the entrance to the courthouse is symbolic of all that has been done for the people by mining coal. The Coalfields Folklife Festival is a yearly celebration for all that coal has given the miners and their families. The festival brings to life for the visitor a way of life still practiced by some of the locals.

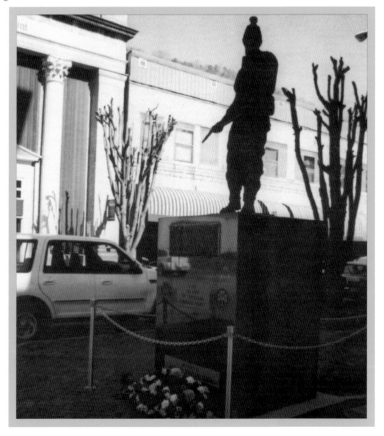

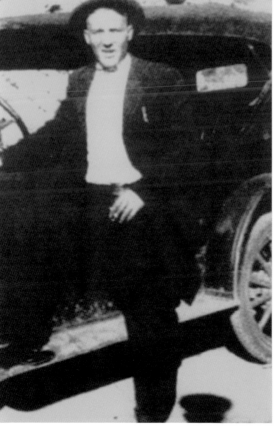

Man and machine have long had a love affair. When cars came to the county, everyone had to have one. They were considered the ultimate must-have in luxury, which has not changed. Today people in the county still favor their trucks, but since four lanes go through the town, many consider sports cars the ultimate must have, buying Mustangs and PT Cruisers to cruise around in downtown.

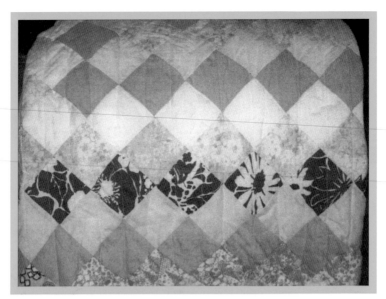

The art of quilting is still practiced in the county. Many of the older citizens go to community centers where they, with the help of a group of friends, hand-stitch quilts. Handmade quilts are gifts that are passed down from one generation to the next. They are considered pieces of art now, but 80 to 90 years ago, they were a necessity for keeping warm during harsh winters.

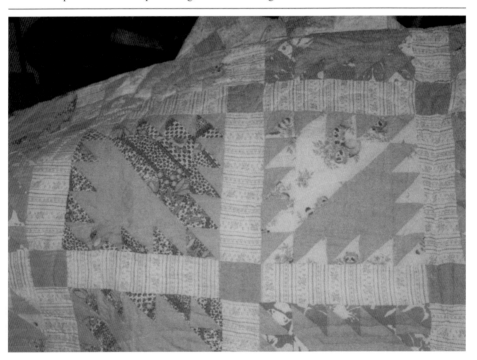

The original United Coal Board started out with seven partners and loans to build the company. With Jim McGlothlin still at the helm, the company was called United Coal by 2004. In 2009, Metinvest Group bought out United Coal. Jim McGlothlin still donates to a number of charities and projects that are dear to him. He once called Buchanan his favorite county on earth. (Then image courtesy of Martha McGlothlin Gayle.)

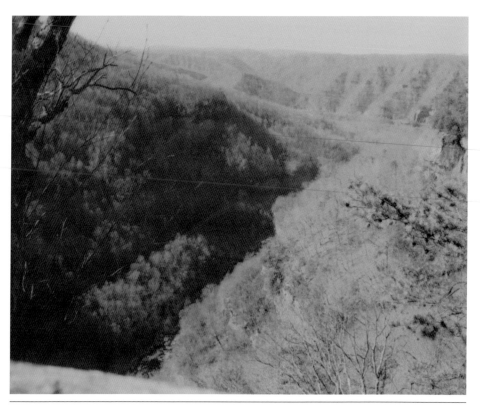

The county is famous for its beautiful mountains and lakes. The area is currently being developed to accommodate tourism on a large scale. The scenery, which is natural to the area, makes it perfect for the campers, fishermen, hikers, and rafters. People visit here to escape from the city and get back to nature with its slower pace. People from out of town are just now finding out what the locals knew all along.

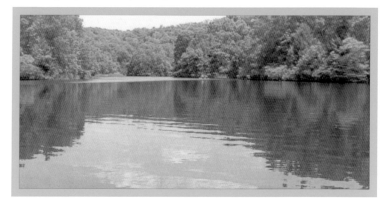

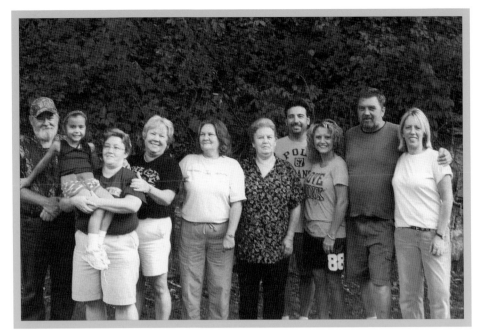

Family reunions are still held year after year and are taken very seriously—only a doctor's note would excuse someone from missing a family reunion.

To many in the community, family is everything, and these events are also viewed as a way to honor a family's ancestry.

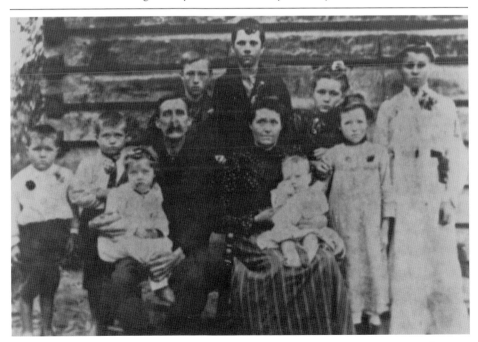

www.arcadiapublishing.com

Discover books about the town where you grew up, the cities where your friends and families live, the town where your parents met, or even that retirement spot you've been dreaming about. Our Web site provides history lovers with exclusive deals, advanced notification about new titles, e-mail alerts of author events, and much more.

MADE IN THE

Arcadia Publishing, the leading local history publisher in the United States, is committed to making history accessible and meaningful through publishing books that celebrate and preserve the heritage of America's people and places. Consistent with our mission to preserve history on a local level, this book was printed in South Carolina on American-made paper and manufactured entirely in the United States.

This book carries the accredited Forest Stewardship Council (FSC) label and is printed on 100 percent FSC-certified paper. Products carrying the FSC label are independently certified to assure consumers that they come from forests that are managed to meet the social, economic, and ecological needs of present and future generations.

FSC
Mixed Sources
Product group from well-managed forests and other controlled sources

Cert no. SW-COC-001530
www.fsc.org
© 1996 Forest Stewardship Council

Find Your Place in History.